CONTEMPORARY CHRISTIAN COLOURING BOOK

ERNESTO LOZADA-UZURIAGA

Foreword
Professor RUTH FINNEGAN

TheLivingTree
publishers

ISBN 978-1-326-96816-8
Copyright images ©2017 Ernesto Lozada-Uzuriaga

FOREWORD

This book with its beautiful images by the admired artist-priest Ernesto Lozada-Uzuriaga is designed as a companion, perhaps a daily one, to contemporary Christian meditation and action. As all acquainted with biblical and classical literature will see it also draws on ancient - no, on eternal - themes and language too. It is a gift, albeit a small one, to the contemporary yet age-old world of today, and for all ages, genders and backgrounds.

Today we are more and more aware of the benefits of the arts – common to all people – of colouring. They contribute to our health – or, better, in the beautiful old way spelling, to our "whole-th". They help to bring us to greater knowledge of our true selves and of our spirituality, to a greater approach to mindfulness, and (why not?) contribute to our entertainment and leisure. They carve a way to the great maker of all, so clearly conveyed in the images here.

May you find your own wholeness and blessing as you complete this and yet again illuminate and colour in glimpses of our wonderful world, created yet again through your very hands as you fill out the decoration of this little book.

<div style="text-align: right">

Ruth Finnegan
Old Bletchley
April 2017

</div>

IMAGE MAKERS
Ernesto Lozada Uzuriaga

In the beginning was the Eikon —the image.

Images—not words decorate the caves of Maros, Chauvert, Altamira, Arnhem Land, Lascaux, Laas Geel, Tassili n' Ajjer and many other places around the world.

The parietal art of early humankind is 'memory made of images'.

In the Judaeo-Christian tradition we affirm that all humans were created to the 'likeness and image (tselem)' of the Creator God. Our innate ability to be eikon-makers is what makes us distinctively human and sets us apart from the rest of creation. The ancient book of Exodus tells the story of how God chose two artists—Bezalel and Oholiab—to make all the art and craft for the Tabernacle. This fascinating tale renders a depiction of a God fully engaged with all the creative endeavours.

This impulse to imagine and create images with shapes and colours is something we share as human beings and cherish in many religions. Figurative images or non-figurative, realistic or surreal, abstract or geometrical, eikon-making, art making, in its different forms and traditions, is our point of contact; the common place where people and religions meet. Visual art in all its richness and varieties are windows into the human soul - a path towards the mystery of the eternal God that bears many names and that we can never fully explain or understand, but only love and trust.

This colouring book invites you to dwell and contemplate upon these images, hoping that in the process something will be revealed unto you.

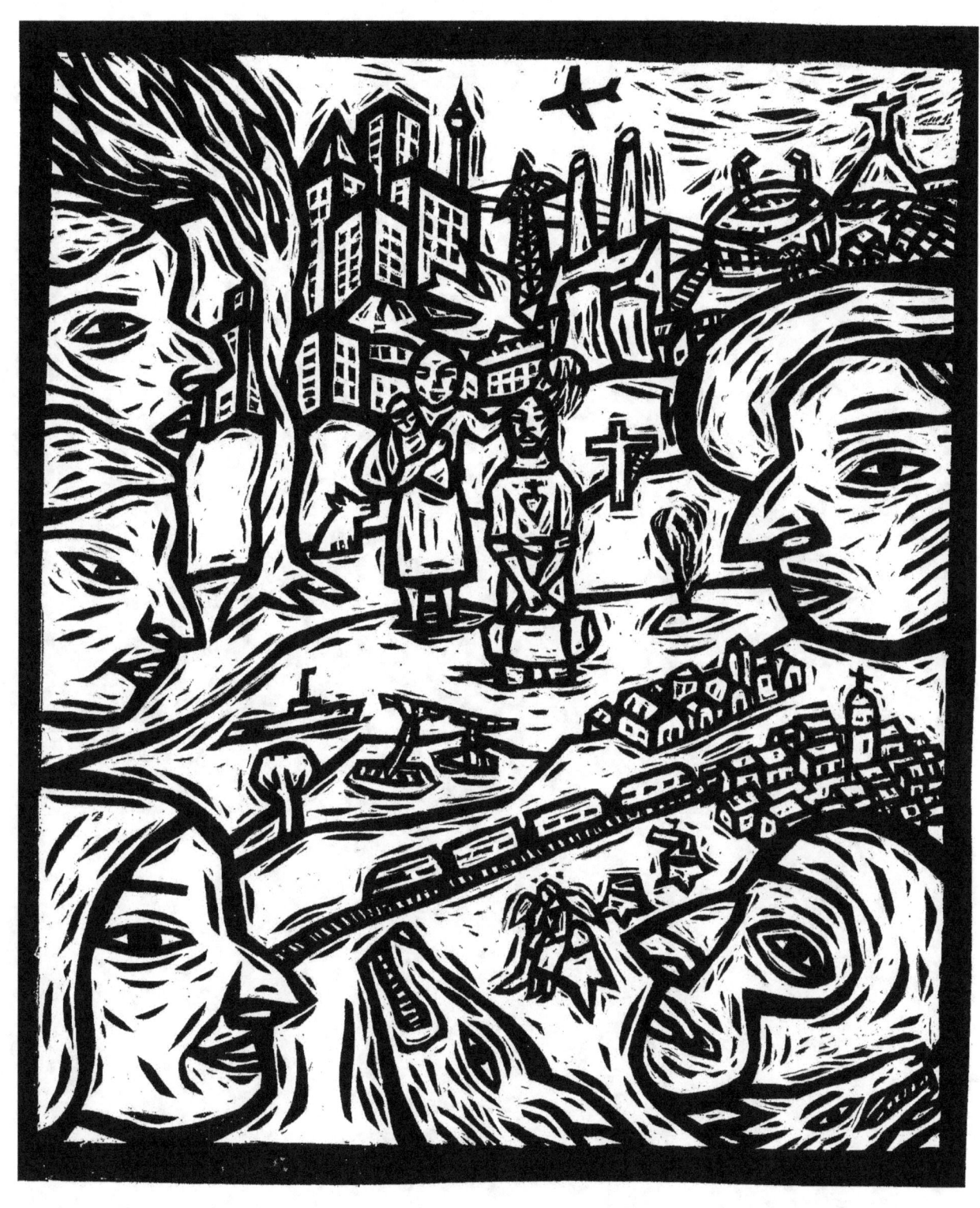

The baptism of Christ before crossing the border

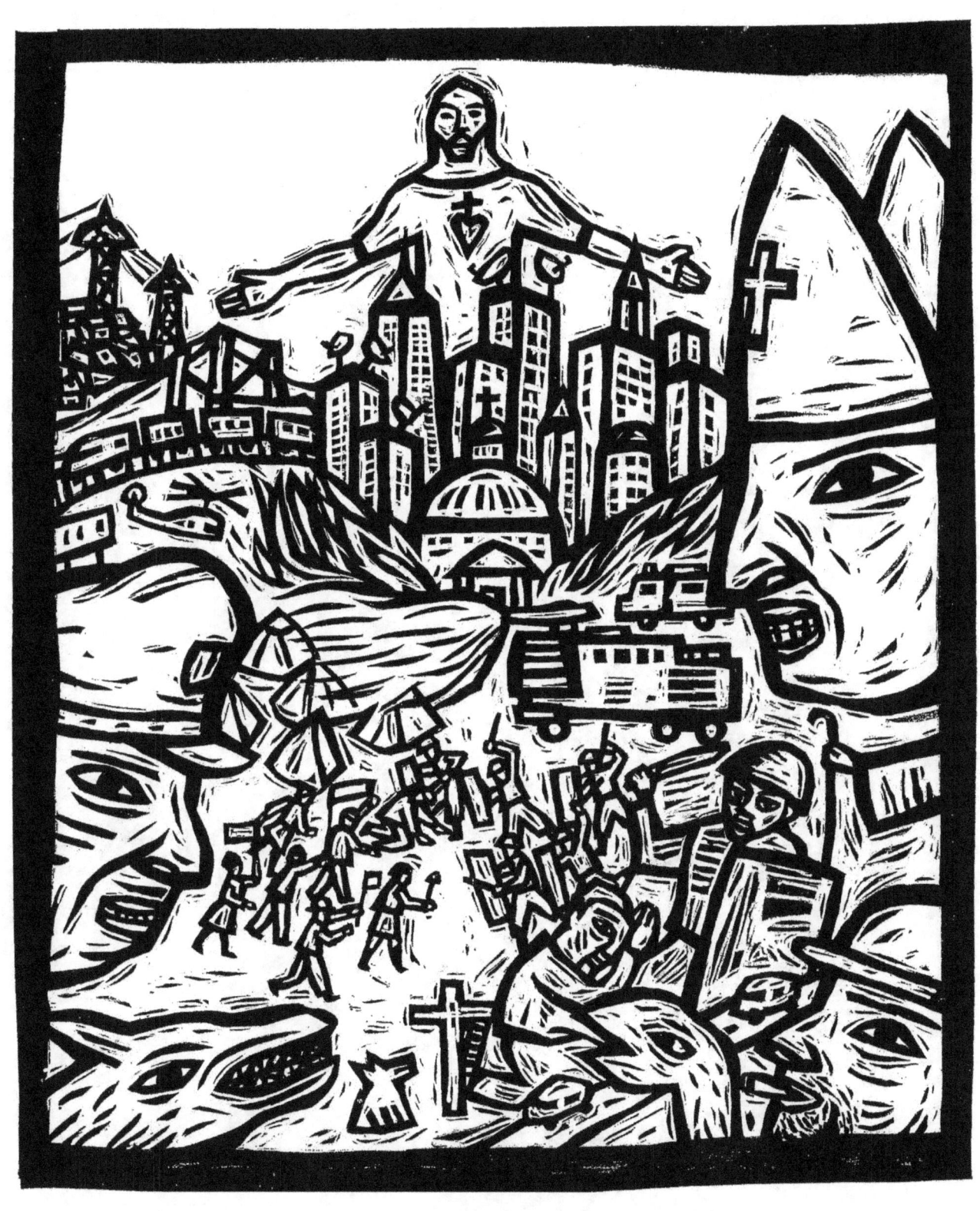

Jesus and the 99%

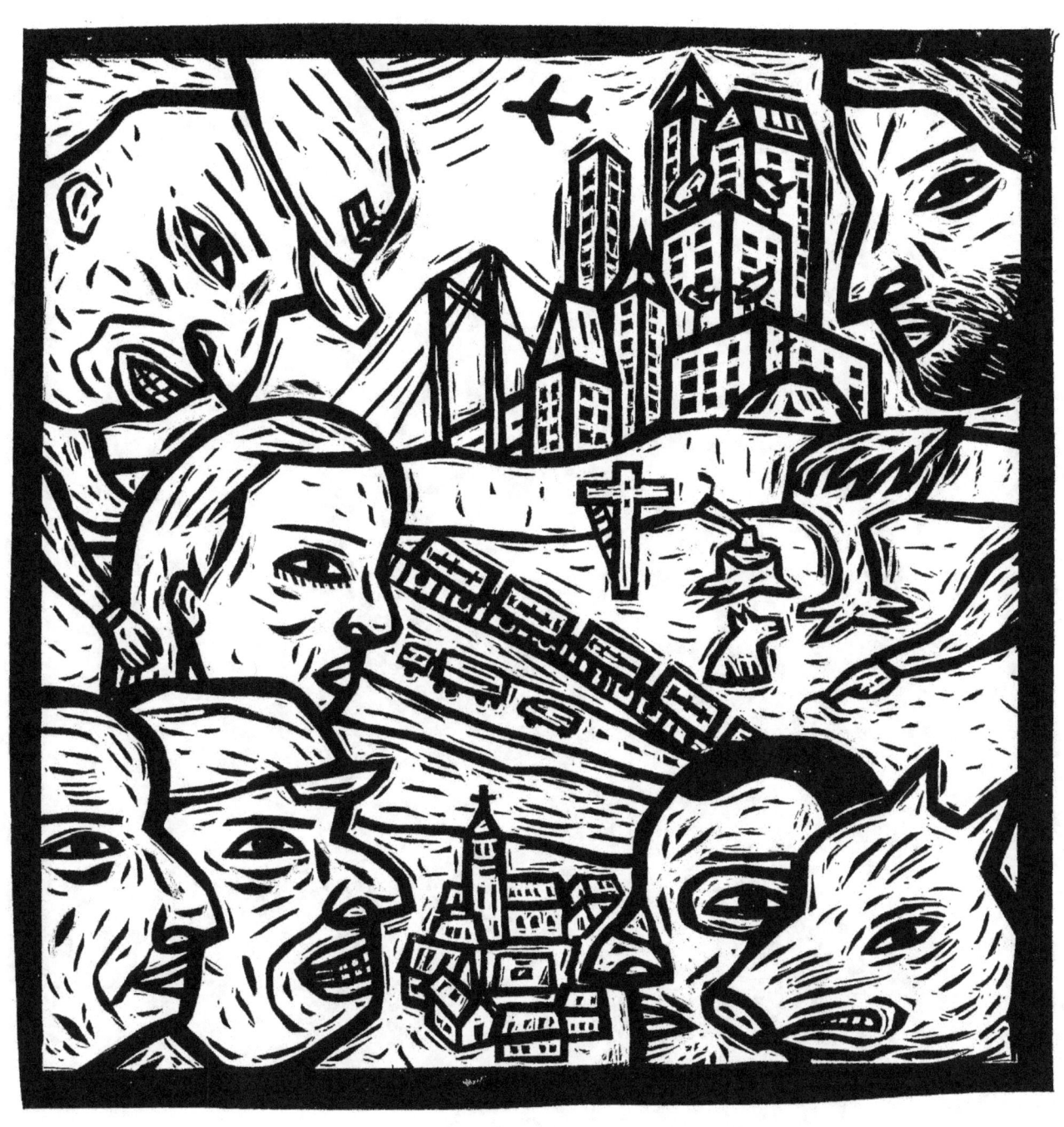

Jesus and the illegal woman

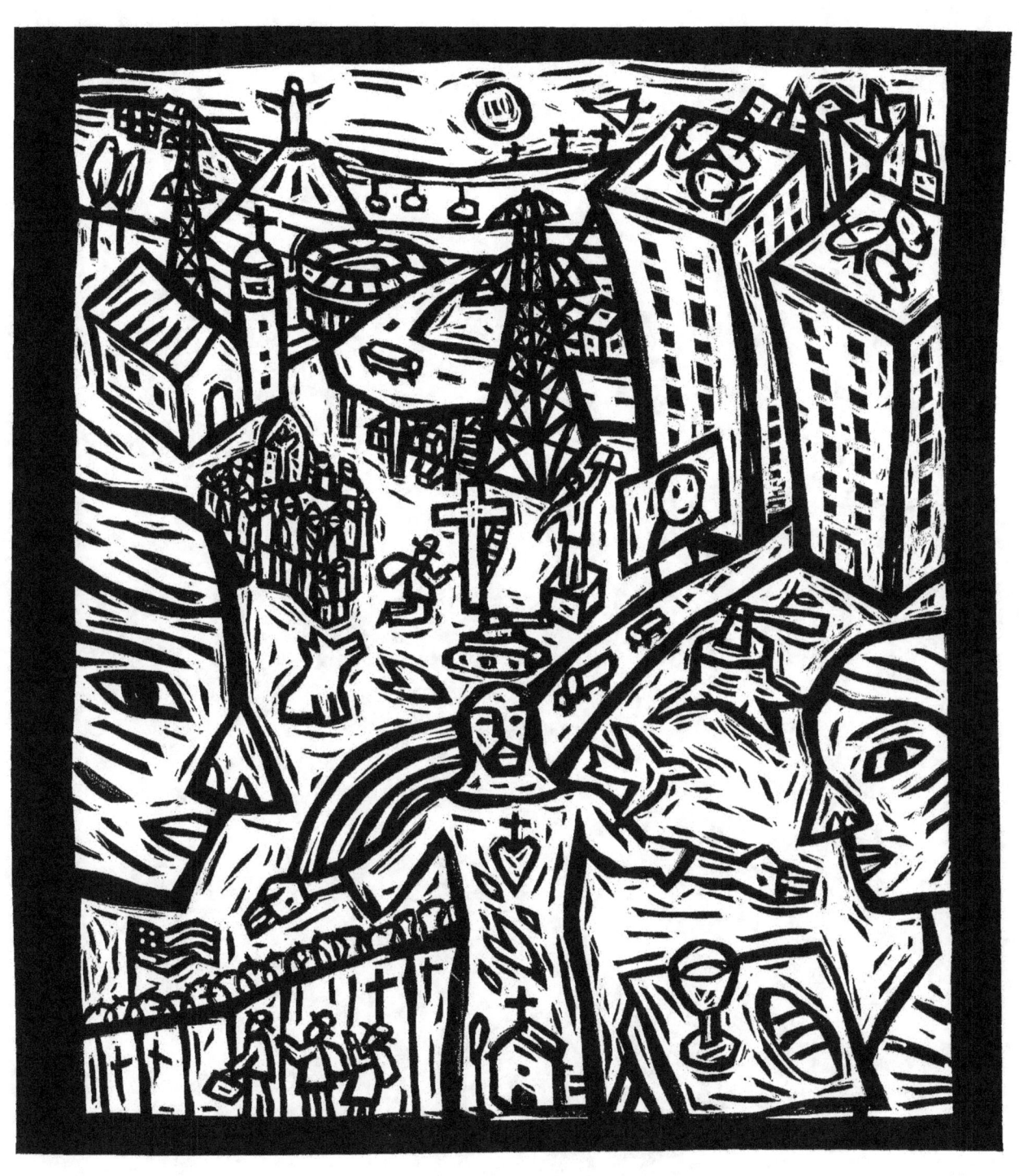

Christ in the city

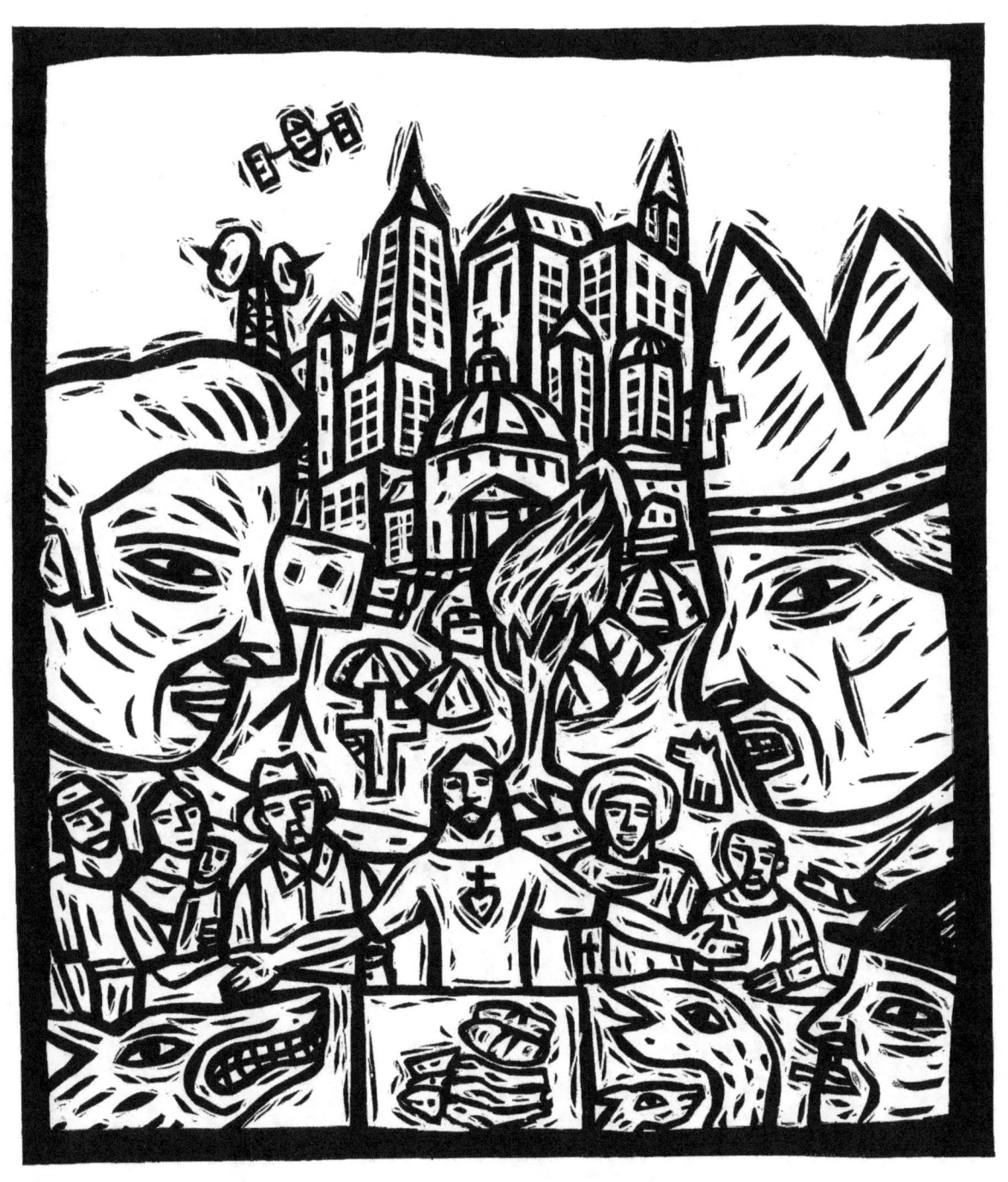

Jesus and the eschatological meal

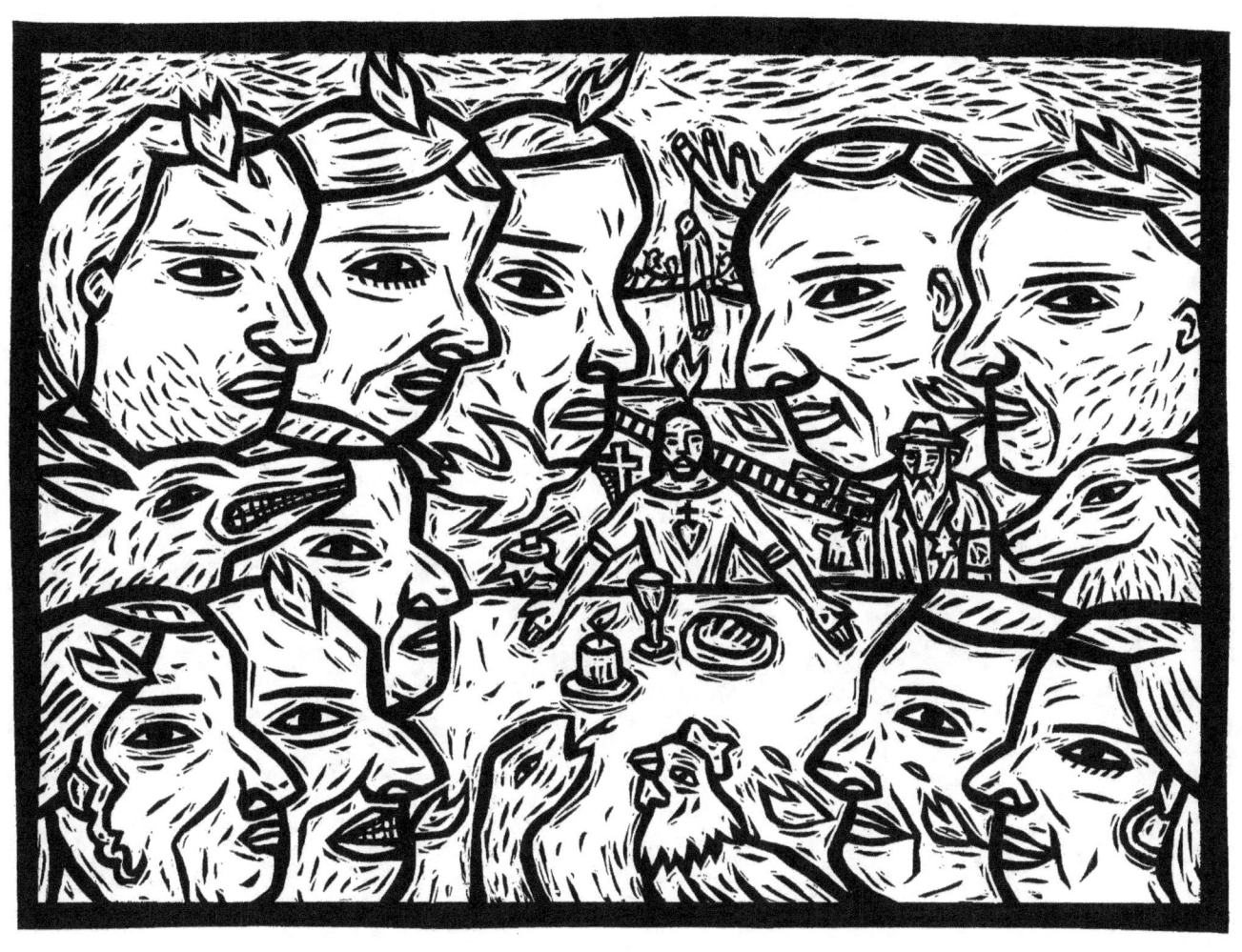

The last supper

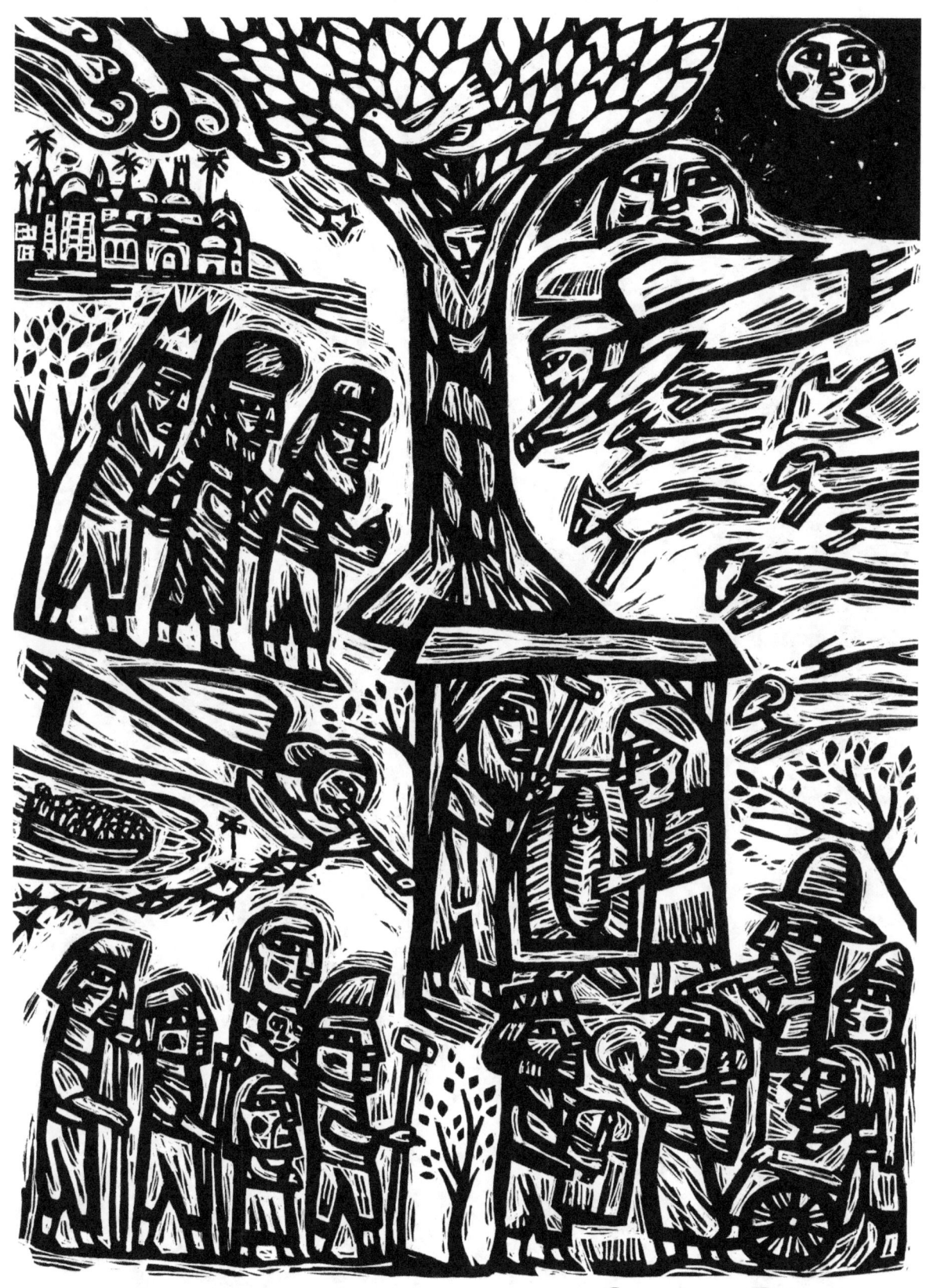

O Come Let Us Adore Him!

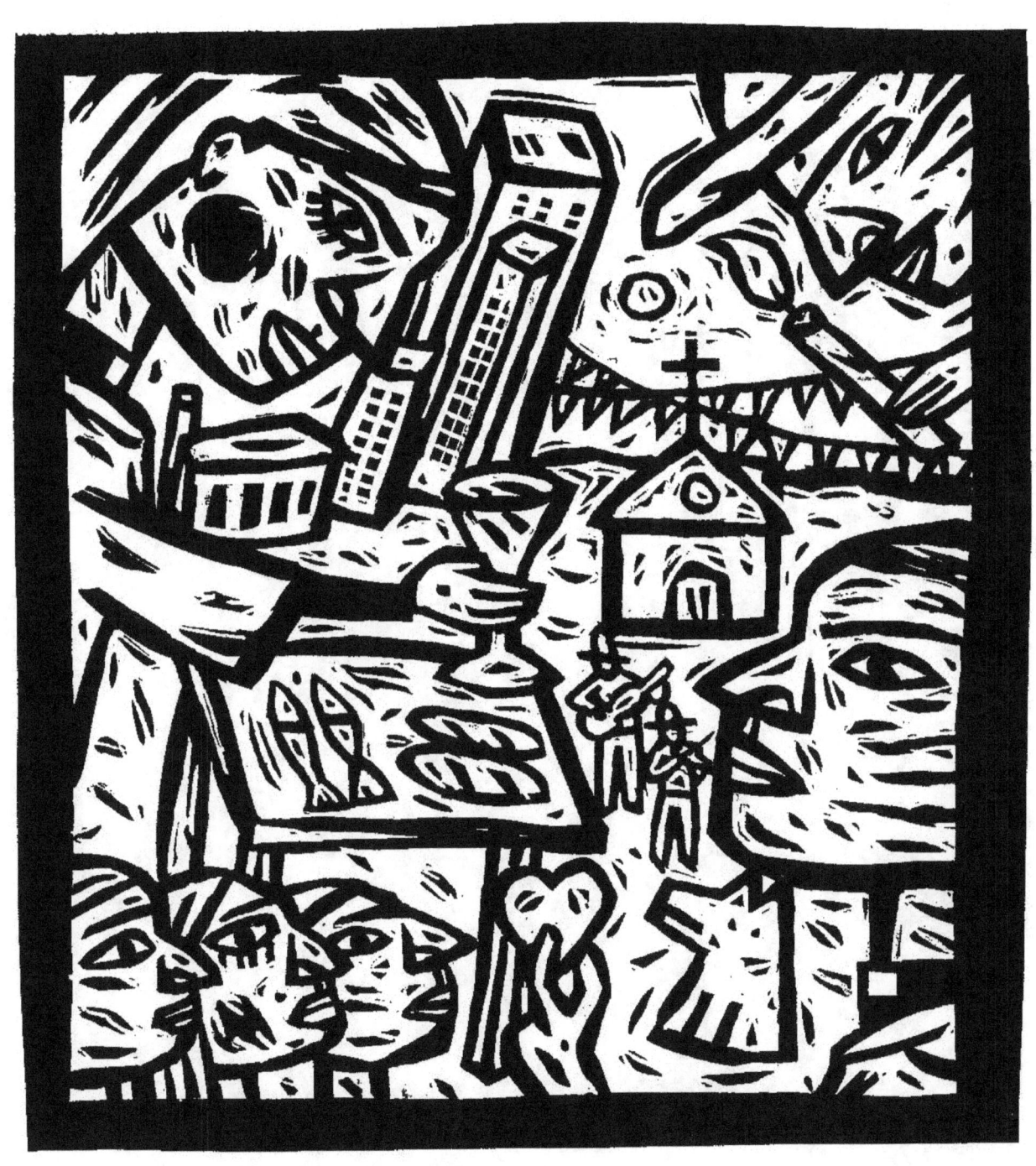

Loaves and fishes
The hospitality of God

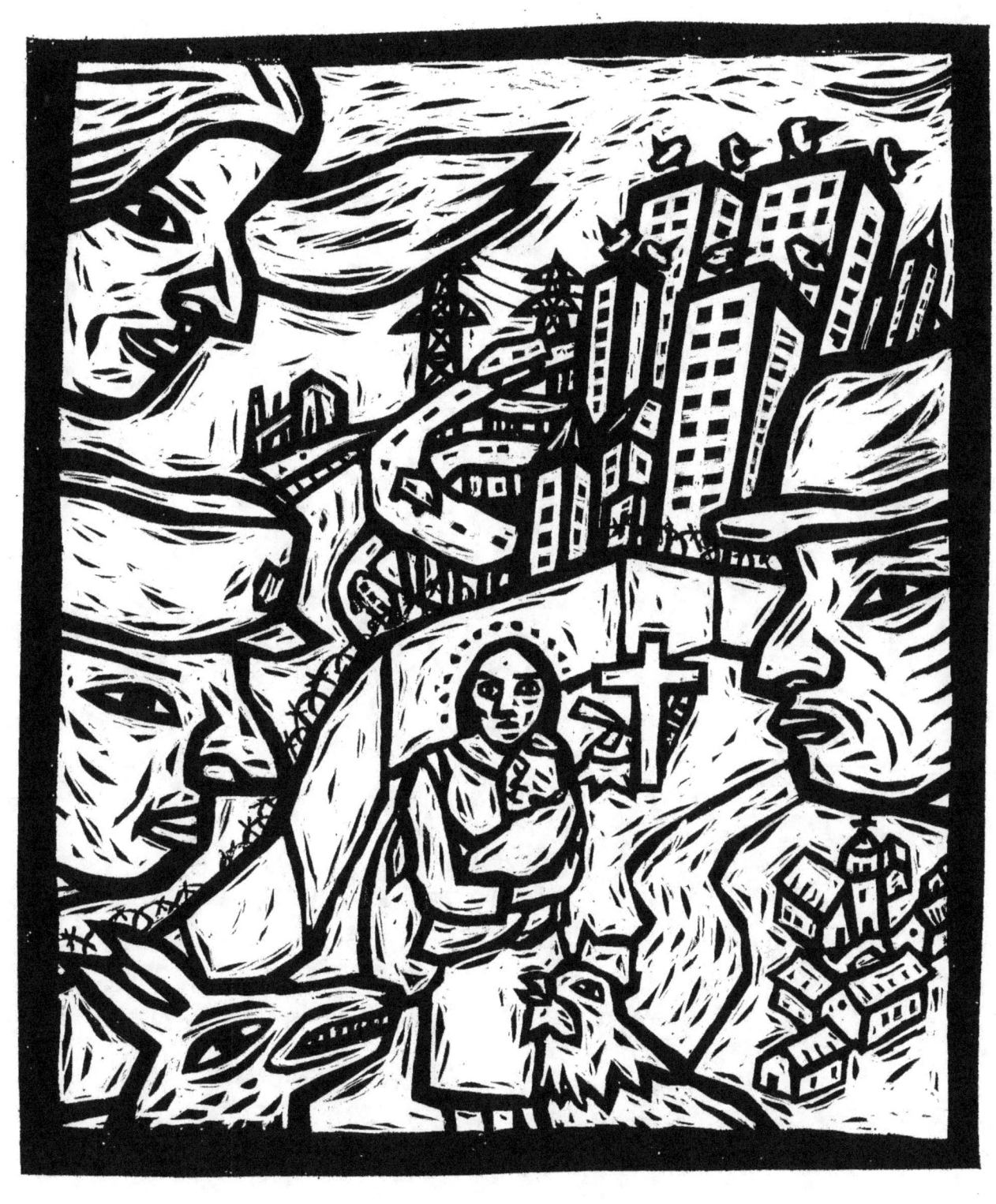

María espalda mojada

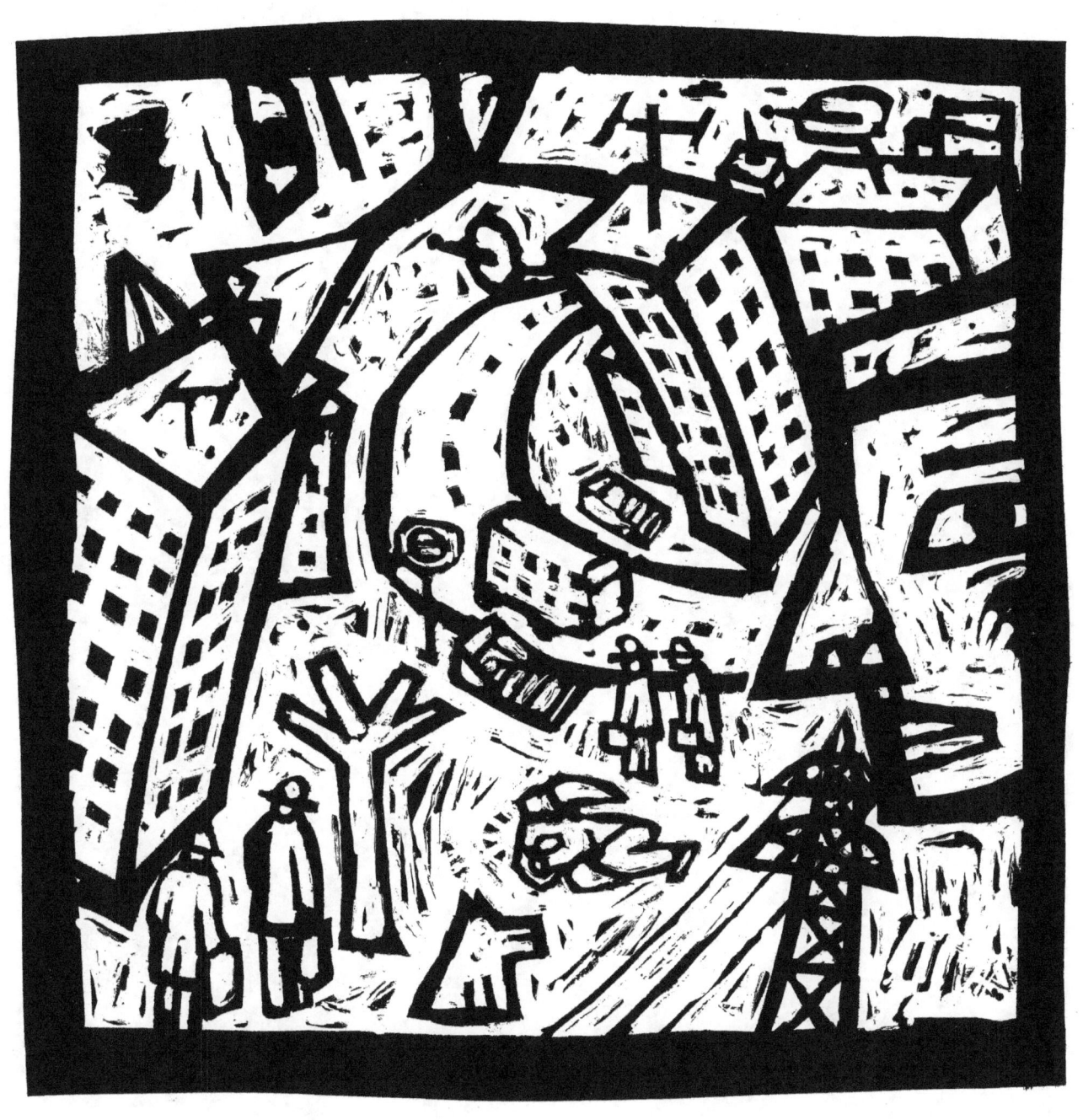

*Entertaining angels
unawares*

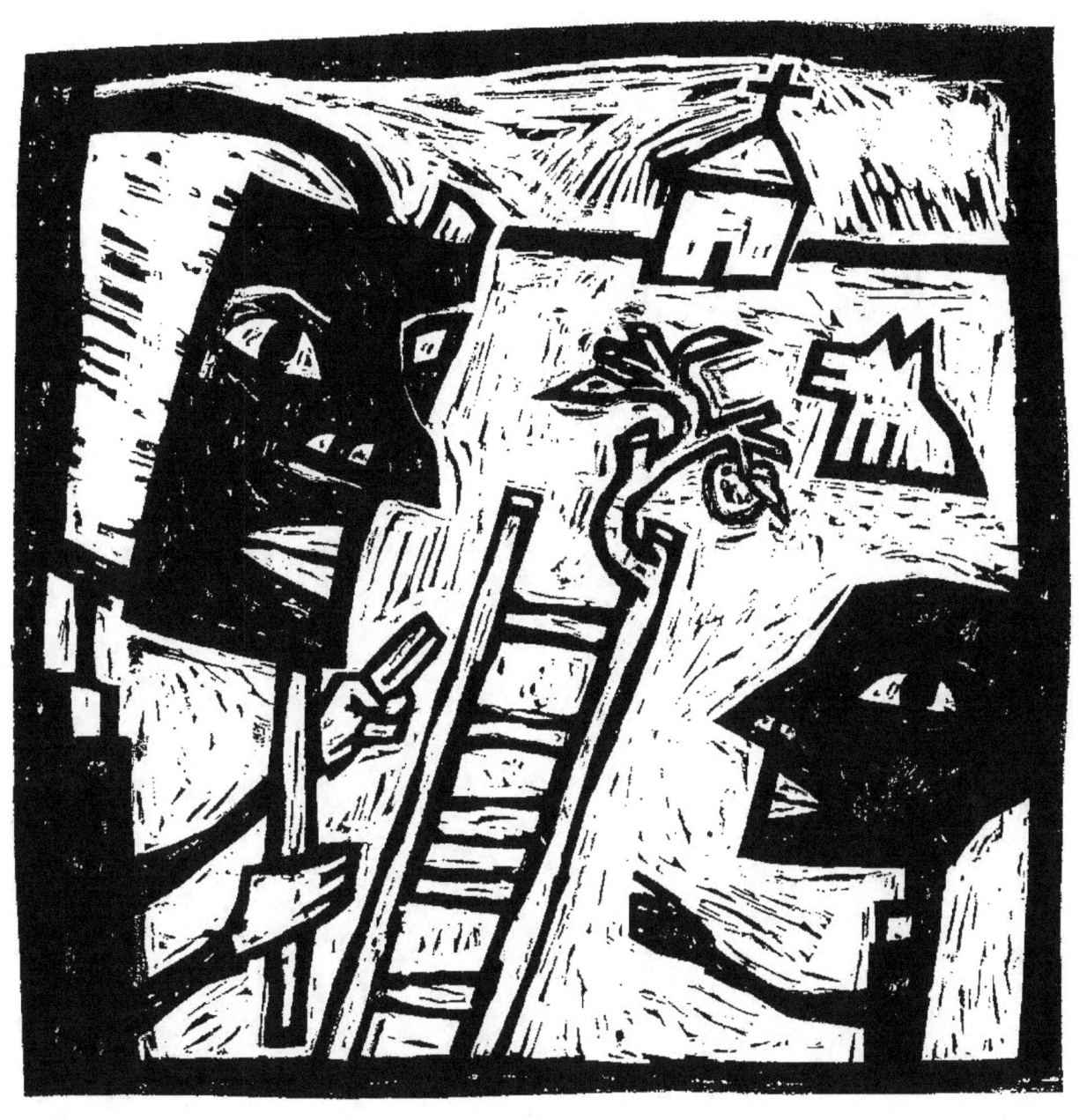

Trying to be inclusive

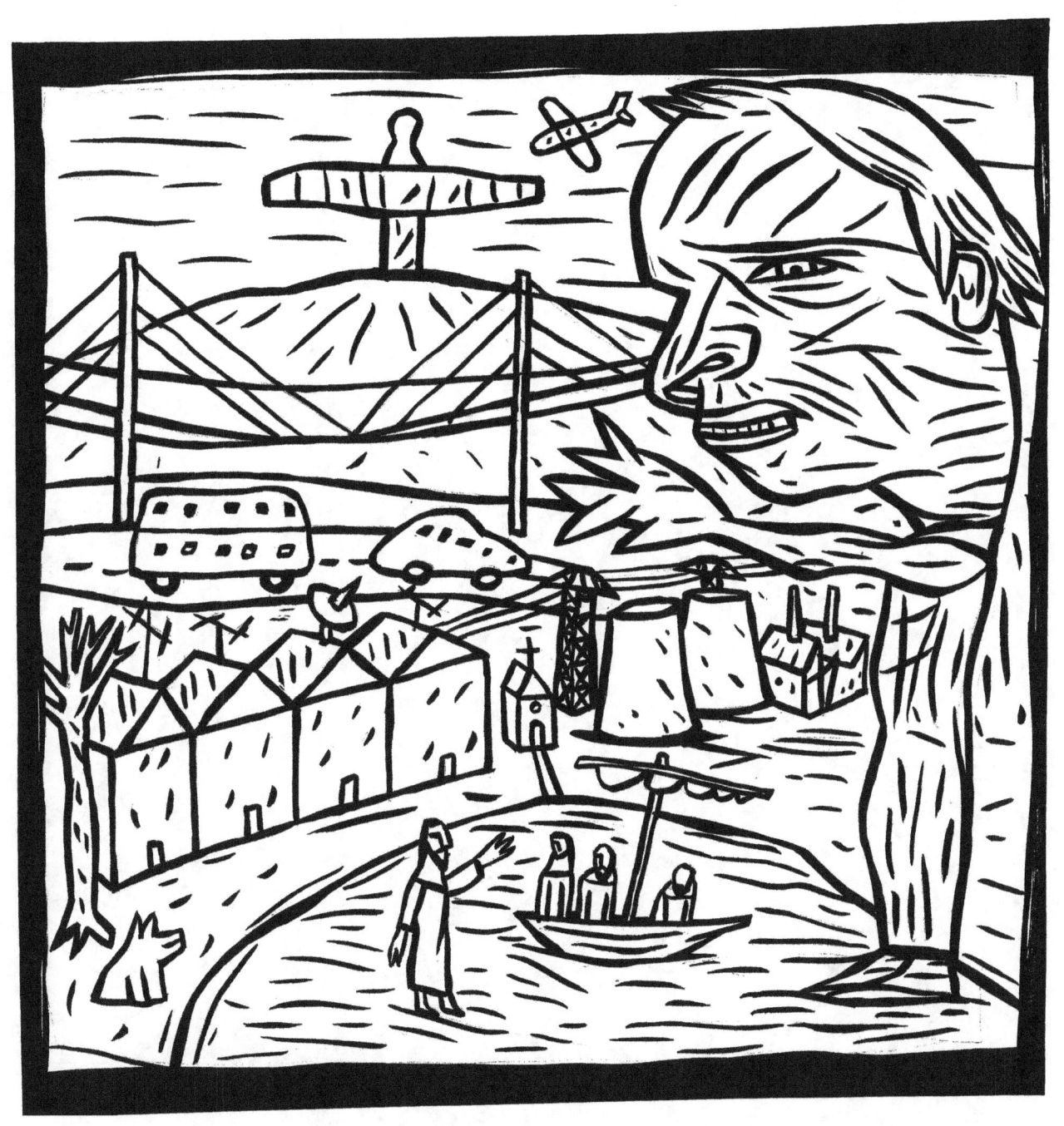

Peter got out of the boat and walked on the water

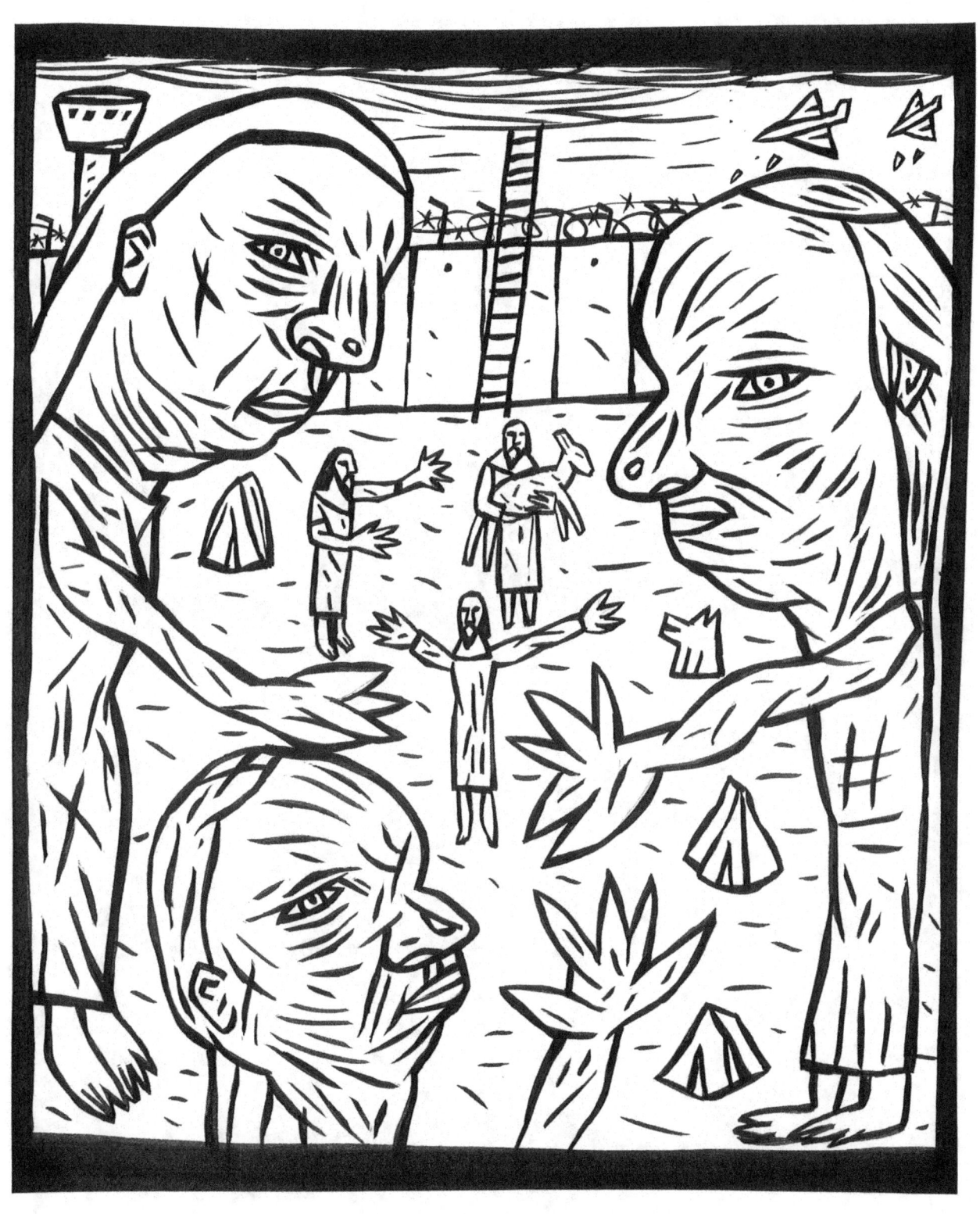

The sacrificial lamb

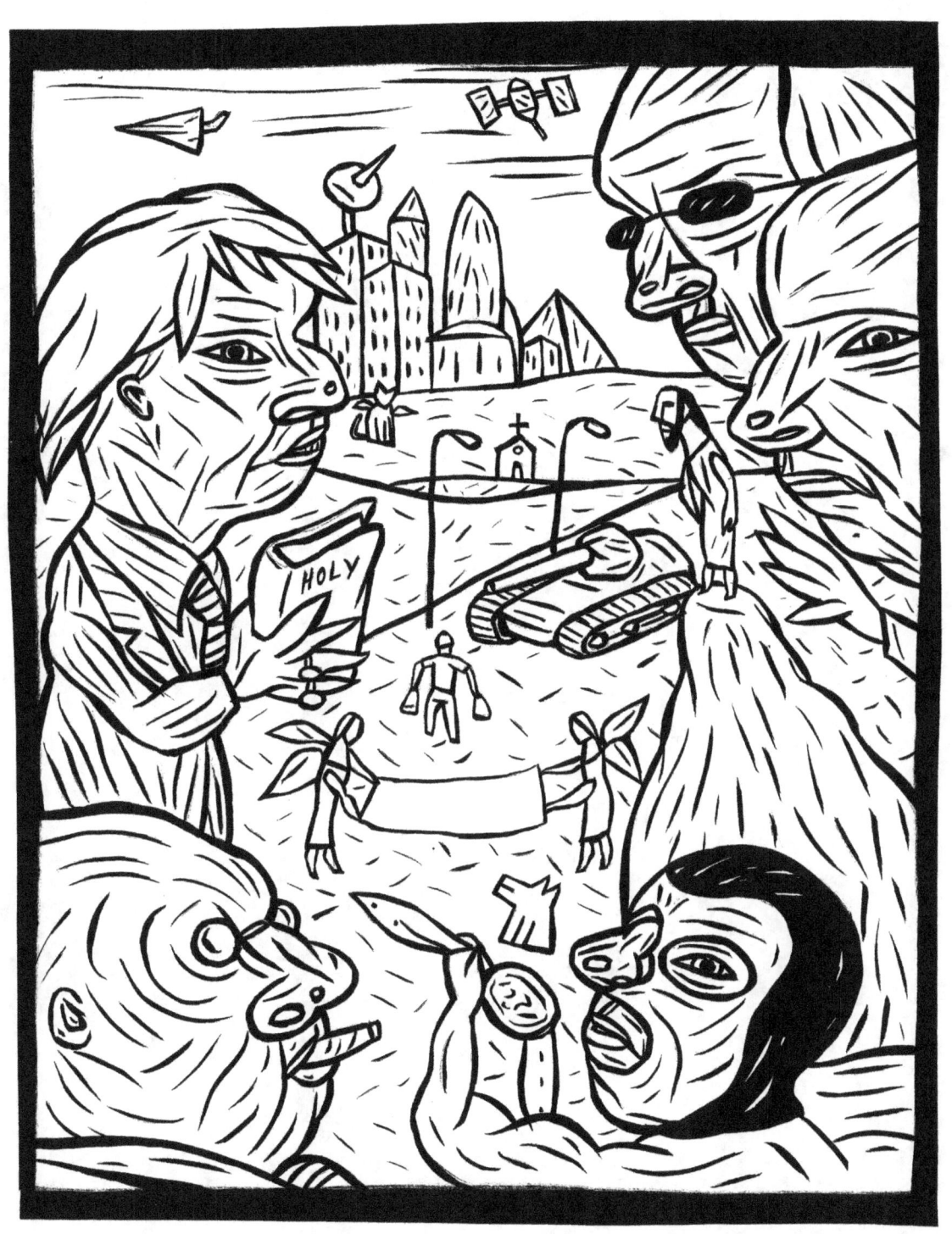

The temptation of Christ

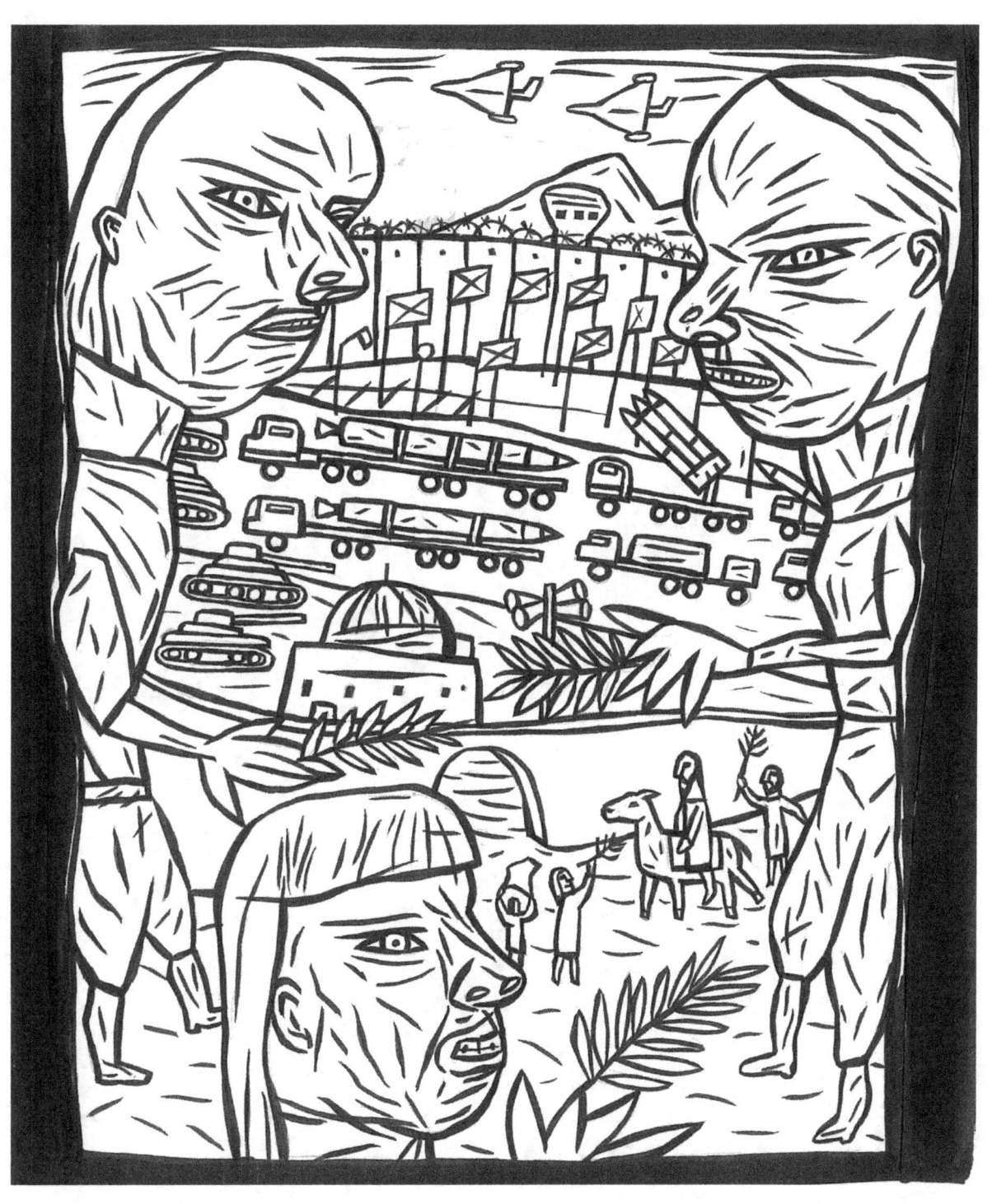

Palm Sunday and the military parade

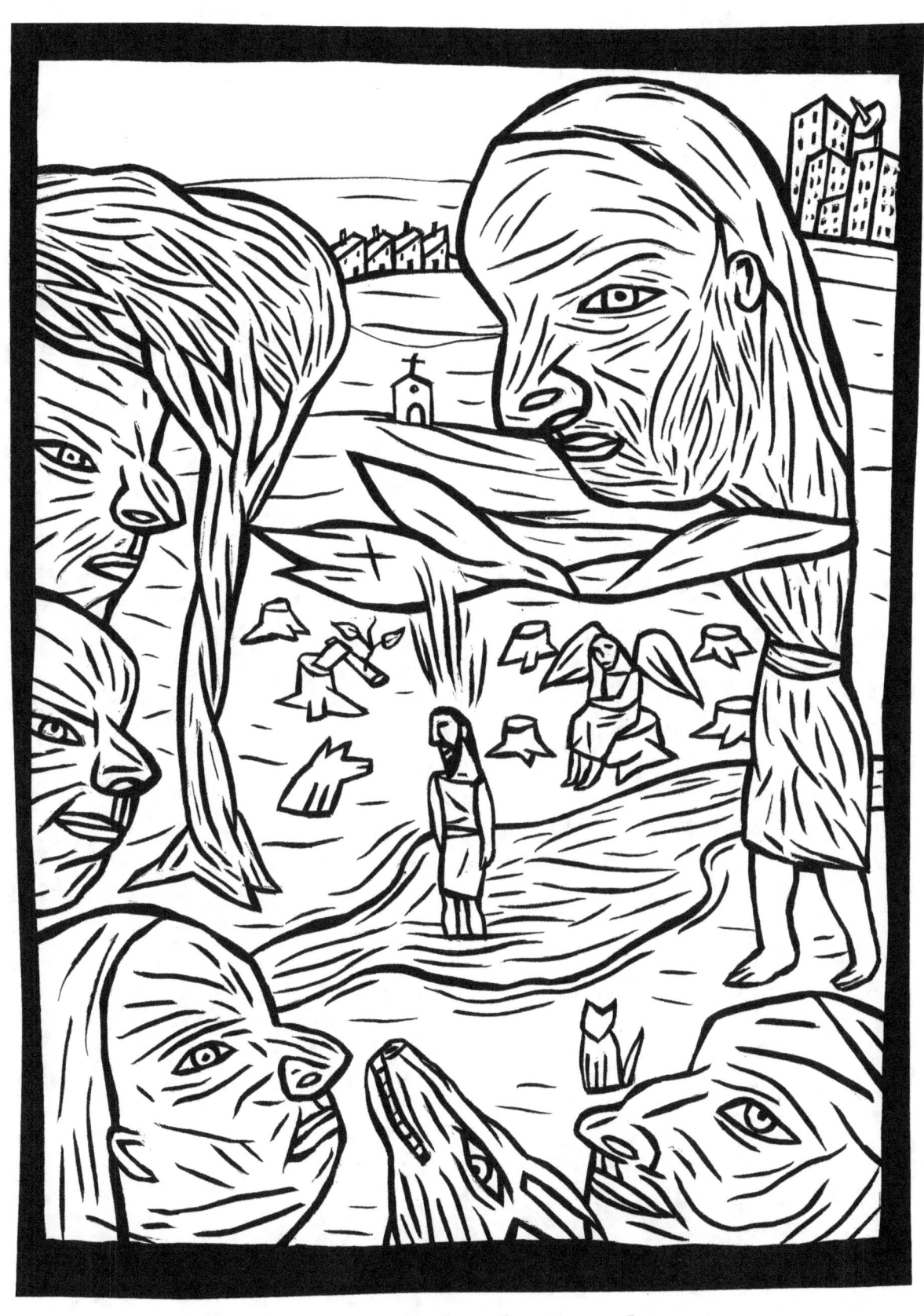

He is my beloved son

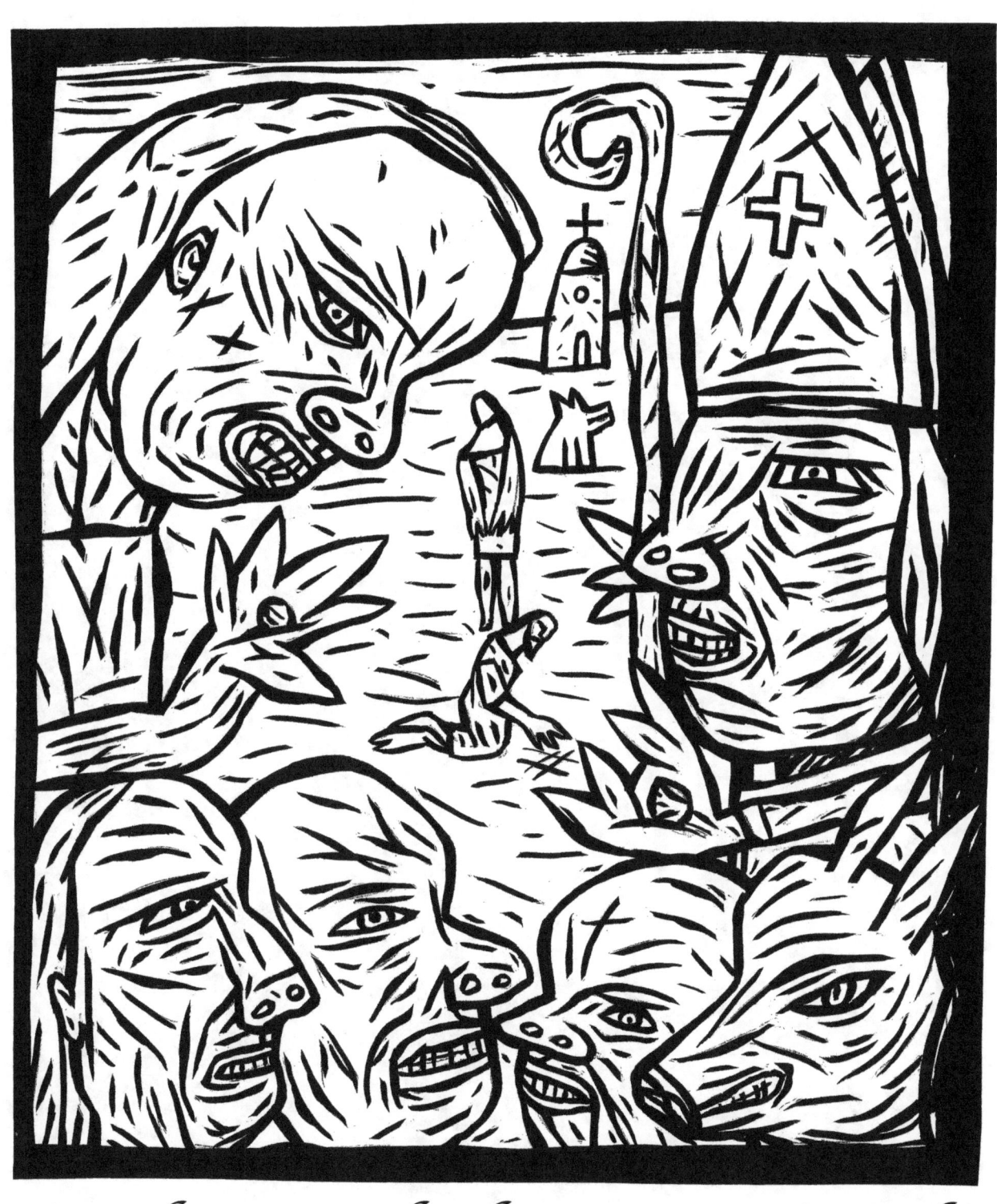

Let the one who has never sinned throw the first stone

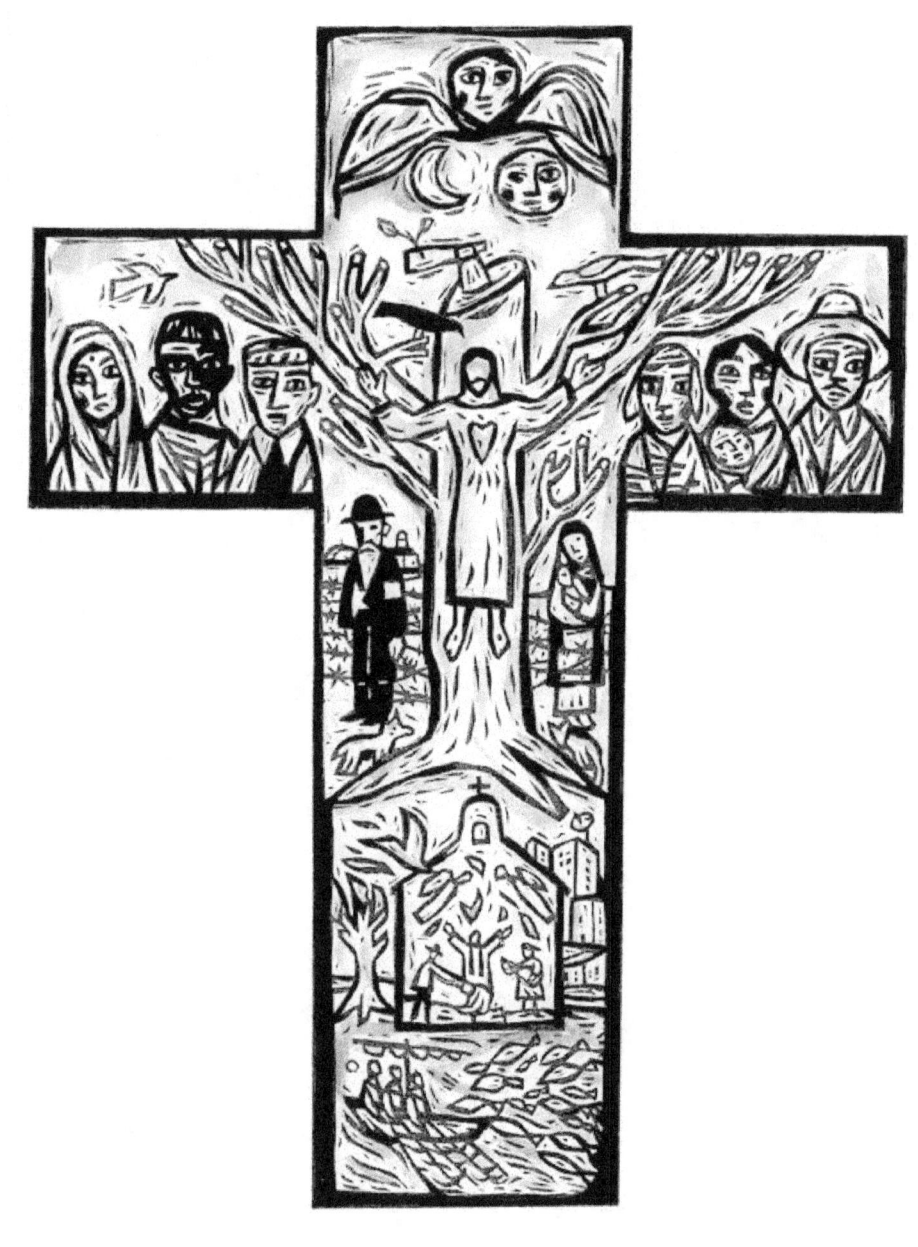

*The Cross
God So Loved The World …*

Ernesto Lozada-Uzuriaga, artist-priest

Ernesto studied art at an early age in his native Peru with personal tutor, Raul Alvarez. He won several awards in various competitions during his school years. However, on leaving school, despite his precocious talent he put aside his plans to study fine art and embarked on studies in theology and anthropology. In 1987 due to the rising political unrest, Ernesto left his country and made his permanent home in UK. In the early 90's Ernesto began painting again. Since then he has built a substantial body of work, finding a distinctive style which reveals both the richness of his native culture and the influence of western tradition. His paintings have been exhibited in the United Kingdom, Europe and the United States, and are held in private and public collections here and abroad. Ernesto trained for the ministry at Wycliffe Hall, Oxford and he divides his time between his creative endeavours and serving his ecumenical Parish.

www.soultravellodge.c

Ruth Finnegan, scholar

Ruth, an anthropologist with long experience of studying African and South Pacific cultures, is an Emeritus Professor of the Open University and the author of many academic and fiction books (several of them prize-winning), most recently of the (also prize-winning) inspirational novels *Black Inked Pearl* and (for young adults) *Pearl of the Seas*. Ruth lives in Old Bletchley with her husband David, married for over 50 years.
www.ruthfinnegan.com

www.ingramcontent.com/pod-product-compliance
Lightning Source LLC
Chambersburg PA
CBHW080849170526
45158CB00009B/2682